C000136186

BRECON
HISTORY TOUR

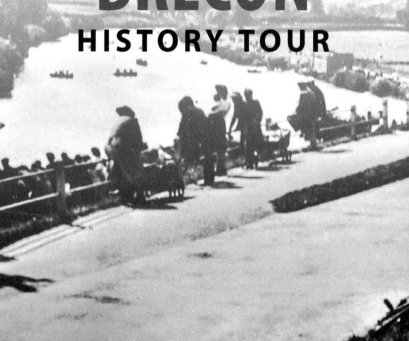

By the same author:

A Pictorial History of Builth Wells (1989)
Photographs of old Builth Wells (co-author, 2009)
Builth Wells Through Time (2010)
A War of Memories (co-author, 2012)
Brecon Through Time (2012)
Secret Brecon (2018)

First published 2018

Amberley Publishing
The Hill, Stroud,
Gloucestershire, GL5 4EP
www.amberley-books.com

Copyright © Mal Morrison, 2018
Map contains Ordnance Survey data
© Crown copyright and database
right [2018]

ISBN 978 1 4456 7823 8 (print)
ISBN 978 1 4456 7824 5 (ebook)

British Library Cataloguing in
Publication Data.
A catalogue record for this book is
available from the British Library.

Origination by Amberley Publishing.
Printed in Great Britain.

ABOUT THE AUTHOR

Malcolm Morrison was born in Newmarch Street, Brecon, in 1948 and was educated at Llanfaes CP School and Brecon Boys' Grammar School, and gained a Certificate in Education and Training from the University of Wales College, Newport. Most of his working life was spent in healthcare as a paramedic.

Always interested in local and family history, he has often lectured on the subject and has been active in setting up an historical archive in Builth Wells, where he has resided for many years. He splits his time between his family, visits to Brecon and touring the UK in his beloved motorhome, *Bertie*.

INTRODUCTION

Apart from a couple of centuries of relative peace when the Romans occupied the Usk Valley, early settlers in these parts led a life that was often violent and difficult. Local skirmishes and power struggles recommenced following the Roman departure until Brychan became king of these lands, changing their name from Garthmadryn to Brycheiniog. Attacks by Saxon and occasionally Norse raiders became a way of life, and the population must have been elated upon hearing of defeat of their Saxon enemies in the eleventh century. Their glee would have been short-lived, however, when the Normans turned their attention west soon after and proved even more capable and ruthless adversaries than the Saxons. It was these Norman invaders who established a castle here in the early twelfth century, around which the town we now know as Brecon, or Aberhonddu, developed and grew.

It soon became a walled town, thriving in the shadow of the castle, as the invaders consolidated their position by strengthening the castle and, soon after, founding the priory that evolved into our wonderful cathedral. Violent resistance continued and although the castle itself never fell, the town was sacked and pillaged several times but somehow survived. It is widely believed that during the Civil War, with the Parliamentary army approaching, the burgesses took the decision to destroy the town's walls to prevent yet another siege and the carnage that would ultimately follow. It is also believed that it was on the orders of Cromwell himself that much of the castle and certain memorials in the cathedral were severely damaged. The borough has enjoyed a relatively peaceful existence ever since and, in spite of the destruction of the town walls, several sections have somehow survived.

So, how would we describe our town of Brecon? For centuries it has been a military town and is extremely proud of this association. Dering Lines camp on the southern outskirts is an important centre of excellence and Headquarters Wales has long been based in the barracks in the Watton, although this connection seems to be coming to an end.

The district is primarily agricultural; various allied trades and industries have come and gone, but Brecon remains a farming community. Our railways have become extinct and the canal that once brought trade to the town is nowadays recreational; however, the town's location – right in the heart of the national park – ensures that tourism is thriving, with many outdoor opportunities for enthusiasts. Mountain biking to satisfy all skill levels is found here as well as hill walking, horse riding, trout and salmon fishing, designated dark sky areas for astronomers and a variety of water sports, all in the midst of centuries of history – something for everyone. Brecon has the infrastructure to sustain all of this and its fortunes are, once again, on the up.

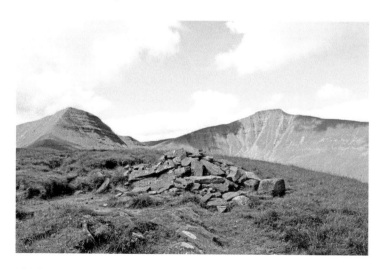

The beautiful Brecon Beacons.

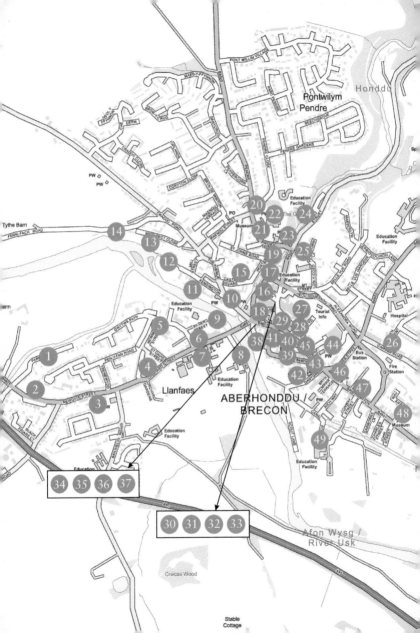

KEY

1. NEWTON FARM

Newton Farm stands between the rivers Usk and Tarell, with the highest peaks of the Brecon Beacons in the background. It was once the home of the Games family, who were dominant here during the medieval period. The Tudor mansion dates from 1582 and stands in the centre of the town's golf course. One of Brecon's oldest houses, it is both architecturally and historically significant, having several Tudor features remaining. It is best viewed from Gwtws or the Promenade boathouse.

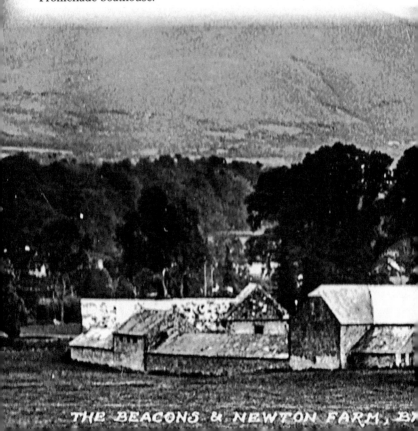

THE BEACONS & NEWTON FARM, B

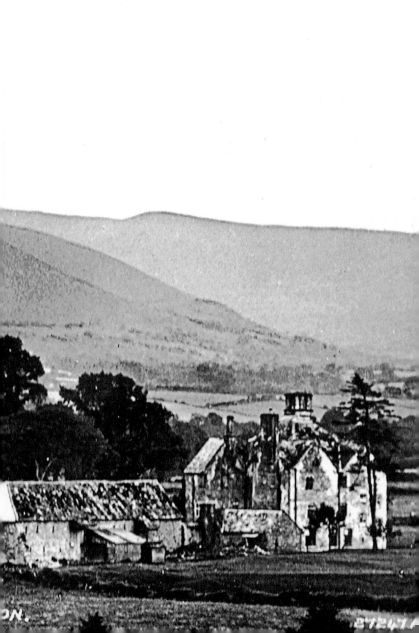

2. NEWGATE STREET

Newgate Street was the location of the county gaol, the site of which can be found on the riverbank. Today it is a residential area but there are several reminders of its past, including part of the walls and the governor's house. Gruesome public executions on the riverbank drew huge crowds back in the day, but the main attraction nowadays is the local pub, the Drovers, which reminds us of the turnpike gates that once stood at every entrance to the town.

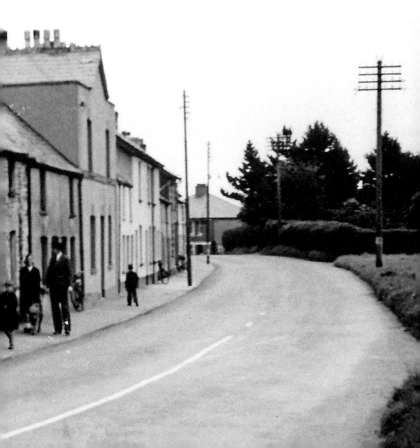

3. PENPENTRE/CHURCH STREET

Here we see farmer David Williams driving cows from the milking sheds to their nearby pasture. Old Castle Farm occupied much of Llanfaes and was – I'm reliably told – the farm that supplied the castle. The building to the far left with the stone staircase was once used as storage by the Brecknock Agricultural Society, and older readers may remember the iconic red and blue Coliseum cinema posters once prominently displayed there.

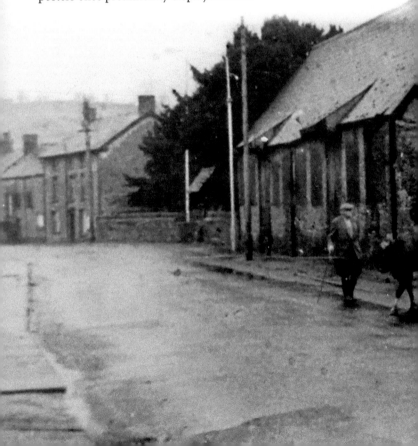

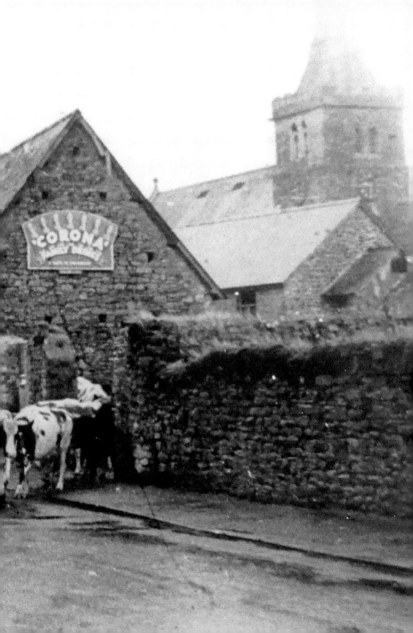

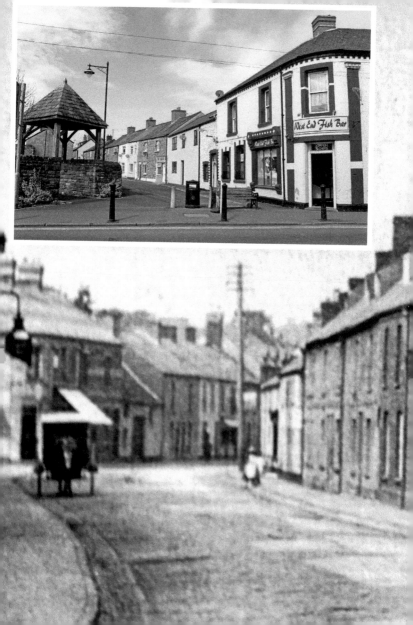

4. ORCHARD STREET

Orchard Street is recognisable despite the passing years. Near the parked bicycle was the Tradesman's Inn (later a fancy goods shop run by the Bowley family), opposite the Three Horseshoes Inn. Behind the carriage, just before the corner shop, stood Llanfaes School, ruled by the fearsome headmaster E. B. Powell during the 1950s. He often cuffed delinquent students with the leather-encased stump of a severed hand. Rumours abounded as to how he lost his hand; we never discovered the truth.

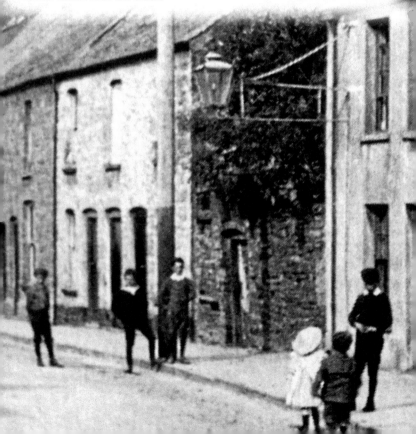

5. NEWMARCH STREET JUNCTION

Newmarch Street, referred to on some early maps as Heol Hwnt (road beyond/yonder), has maintained its residential status, unlike many of its neighbours. The old chapel is located at what once was the junction of Newmarch Street, Silver Street, Gwtws, Cwrt-y-Mor and Spring Gardens. Once a mainly residential area, much of the housing has disappeared, replaced by a plethora of unspecific commercial buildings.

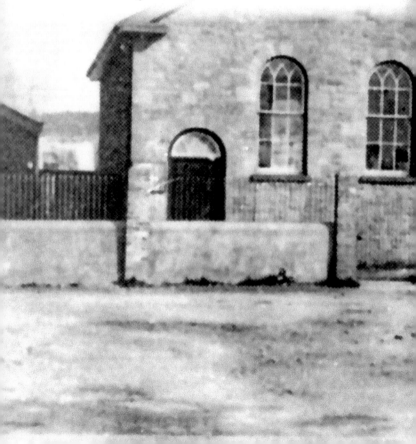

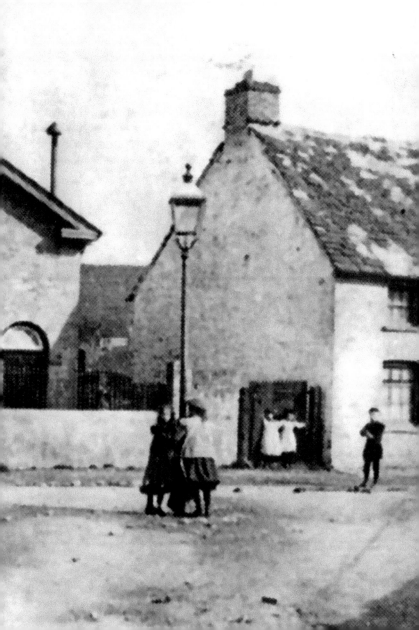

6. BRIDGE STREET

Bridge Street once included Sullivan's hardware store and Hilda Davies' tiny tobacconists near the bridge. The transport café The Greyhound stood near the three stone steps midway along the terrace. Victor Morris' grocer's shop at No. 17 Bridge Street was the largest of the shops that graced the streets of Llanfaes. Victor Morris can be seen in the inset image next to his mother and father William. The group to the left includes Mrs Mantle (Dilly Frost), Mrs Wilding and a G. Lumley.

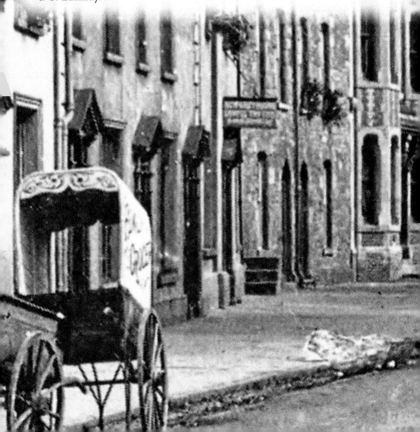

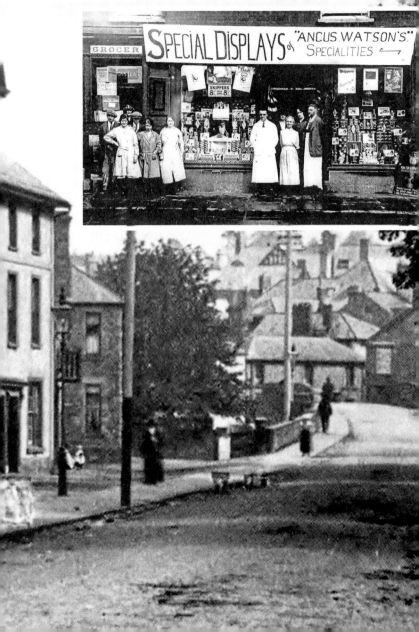

7. CHRIST COLLEGE

Christ College was established by Henry VIII in 1541. For 300 years before this it was a Dominican friary. A certain Bishop Lucy is credited with giving the school its 'ghost' and legend; however, anecdotal pranks seem to be more common than actual ghostly sightings. School House (the building to the left) dates from 1853, and though the building's usage has changed over the years, its charming exterior remains the same.

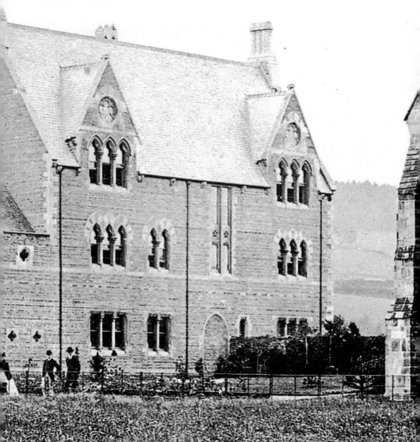

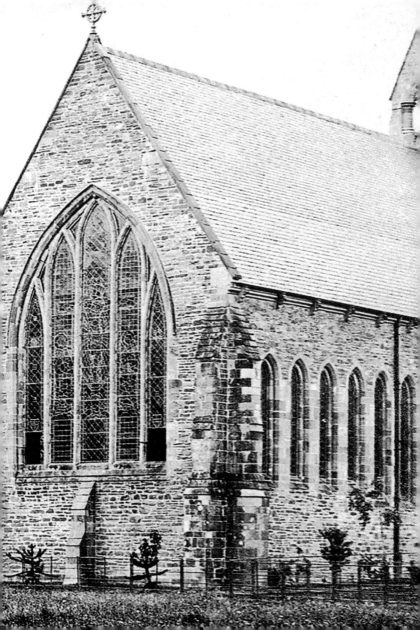

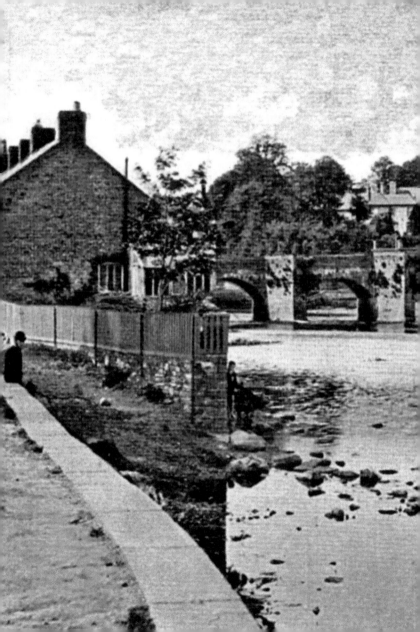

8. THE BRIDGE FROM DINAS ROW

All too often the Usk overwhelmed the flimsy flood defences and although much of Llanfaes suffered, the fury of the waters was reserved for Dinas Row. The pretty cottages flooded with alarming regularity and were eventually demolished. The present Elizabethan bridge replaced a medieval structure washed away by floods in 1535. Although widened and repaired in the eighteenth century, it was never intended to carry modern traffic and was further altered during the 1950s. The current bridge is functional and safe but must rank among Wales' most unattractive.

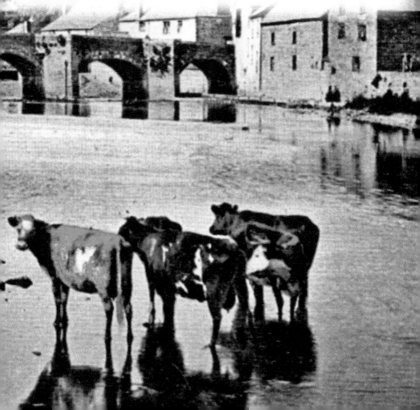

9. LLANFAES PONY SALE

This image shows horse trading in Llanfaes. Most towns and villages held horse fairs until the mid-twentieth century. This slightly over-exposed photograph from the 1930s shows how popular the event was. Note the plank barrier in the foreground, a feeble attempt to keep the waters of the River Usk in check. Little wonder that Brecon – Llanfaes in particular – suffered regular flooding until recent times, when proper flood-prevention measures were put in place.

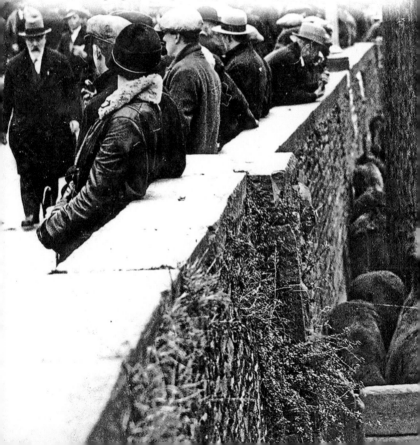

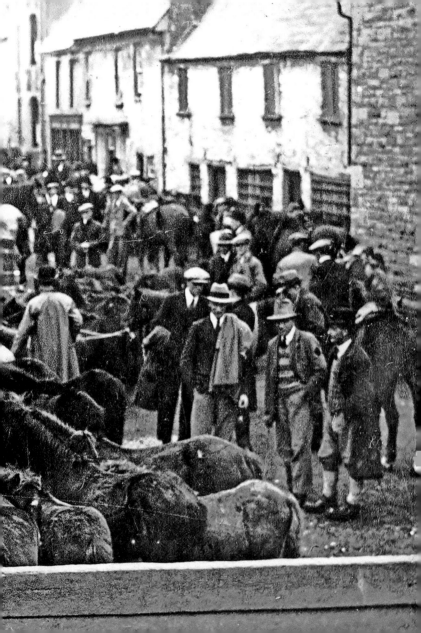

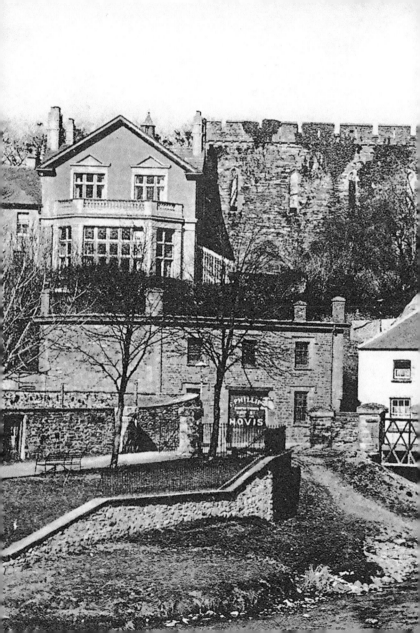

10. WATERGATE AND HONDDU BRIDGE

This picture from the early 1960s shows the old Watergate and Castle Street bridges and the pretty Watergate Mill (before the word Watergate became infamous). The waterwheel is still in situ. In the background we can see the ironwork of the huge railway viaduct, which was mainly stone built as we shall see shortly. Both bridges have been replaced and the riverbank substantially altered since.

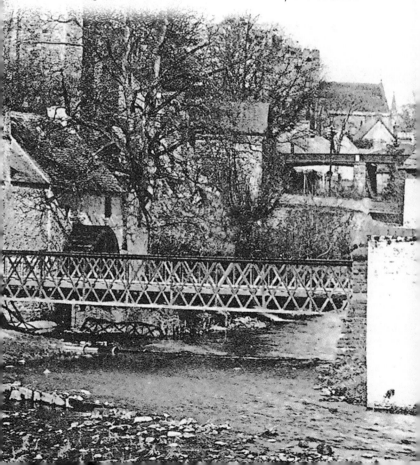

11. THE PROMENADE

The Promenade was developed to attract visitors to Brecon, opening in 1894. In its heyday miners and factory workers from the South Wales valleys flocked here to enjoy the ambiance. It remains a very popular area for visitors and local people alike.

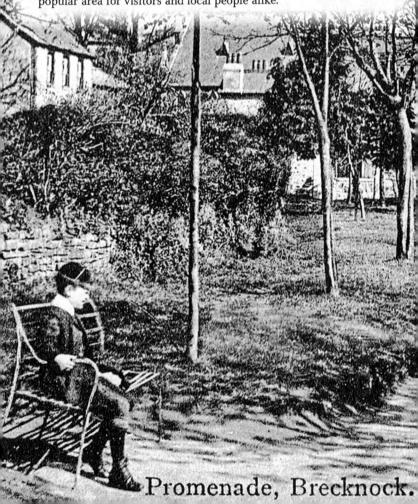

Promenade, Brecknock.

12. THE USK WEIR

The weir at the canal intake originally diverted river water towards the large mill that stood nearby. The weir provided deeper water, allowing for swimming and boating, and helped to make Brecon a popular destination during the long hot summers of bygone years. Families from the industrial Merthyr, Rhondda and Gwent valleys flocked here to relax or to hire a boat on the river.

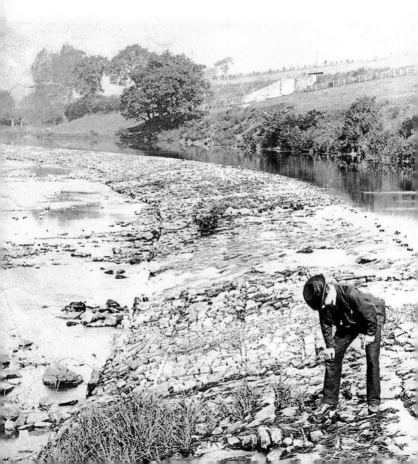

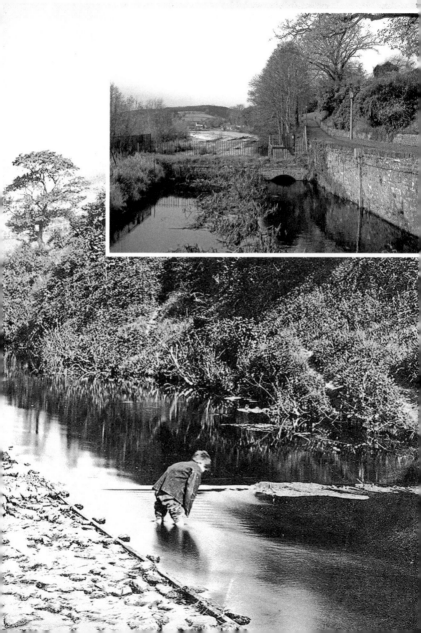

13. RIVER USK FROM THE PROMENADE

A postcard from the Promenade by local photographers Clark of Brecon shows how popular boating and promenading was. Note the large audience watching the bathing and the ferry landing stage on the Newton side of the river. Near this part of the Promenade once stood a bandstand where the crowds were entertained. The Promenade Swimming Club is no more, but boating and promenading are still popular.

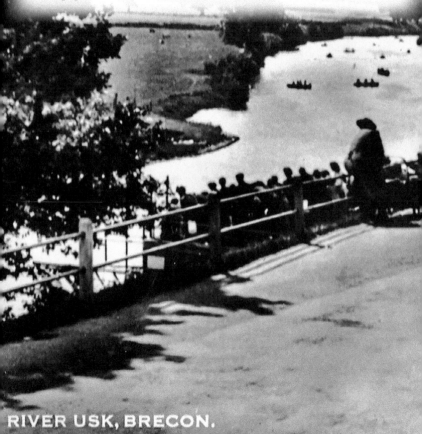

RIVER USK, BRECON.

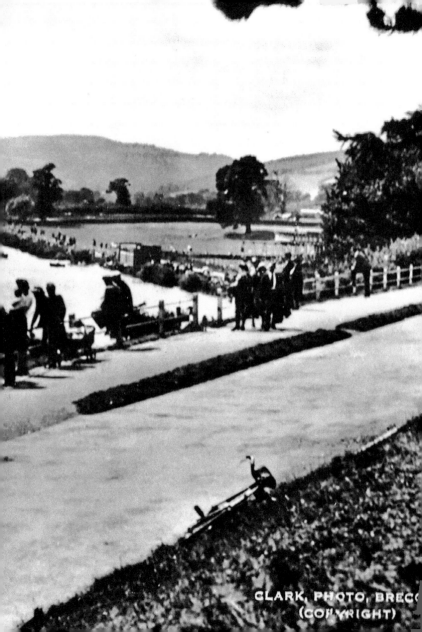

CLARK, PHOTO, BRECO
(COPYRIGHT)

Boat House : Brecon.

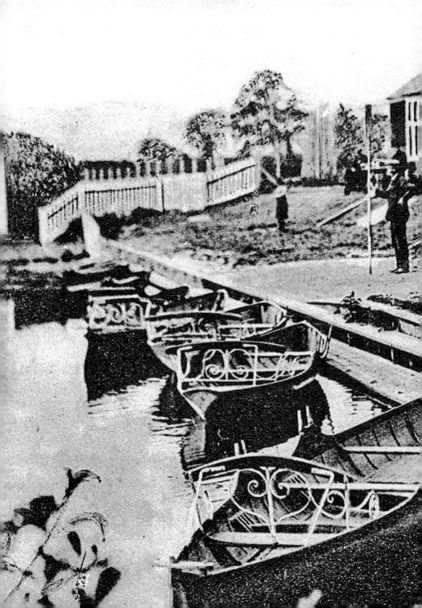

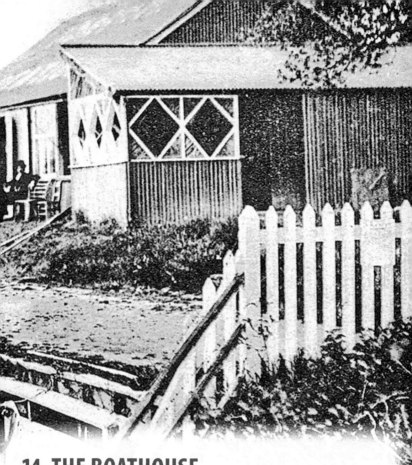

14. THE BOATHOUSE

The main attraction on the Promenade is the boathouse, where we can see some of the rowing boats for hire. The complex was rebuilt soon after the big freeze of 1963 with better café facilities, amusements and boat storage. The popularity of the boathouse was extremely high during this decade and although it may have diminished slightly, it is still a major attraction, especially during the summer months.

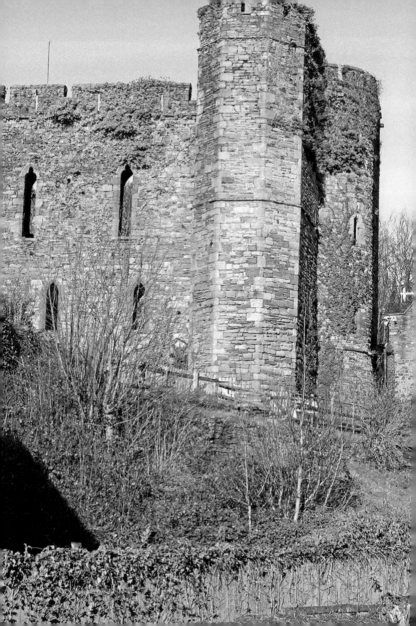

15. THE CASTLE

Brecon, unlike its neighbours, was a walled town that grew around its Norman castle. Much of the walls remain, but perhaps the most interesting part is hidden from sight. On the hill above the bridge in the grounds of the Bishop's Palace are fragments of the keep. Just to the left, hidden by dense undergrowth, a cannon points along Castle Street – a veiled threat high above the town.

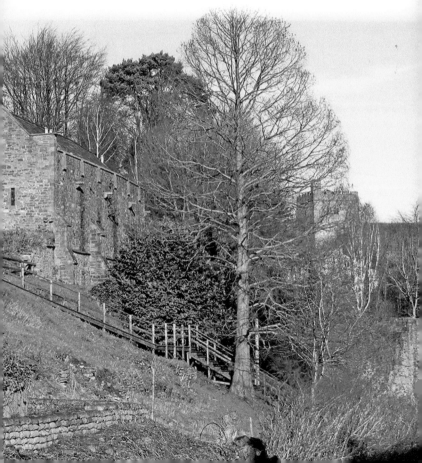

16. CASTLE STREET

Castle Street was Brecon's original main street. It once thrived with shops, tearooms, bakers and traders of every kind, with the nearby Market Hall drawing crowds into its precincts. The bridge has been replaced and traffic can no longer pass over, but Castle Street was once the most important street in Brecon, leading to and from the castle.

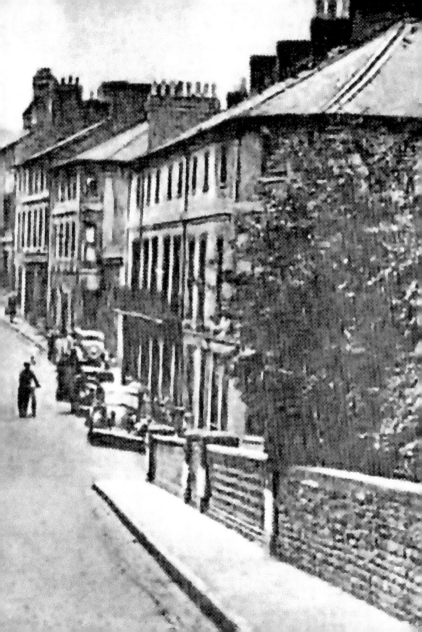

17. THE VIADUCT

The mammoth railway viaduct dwarfed the whole of this area of the Struet and Postern districts. The ironwork from either side was removed soon after the closure of the railway, just before this photograph was taken. The arches, as we can see, were utilised for a variety of workshops and storage areas. Two of the large pillars remain in the Postern – ivy-covered reminders of Brecon's railway heritage.

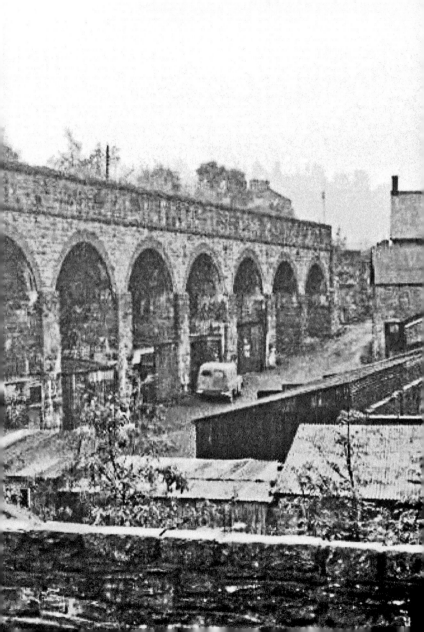

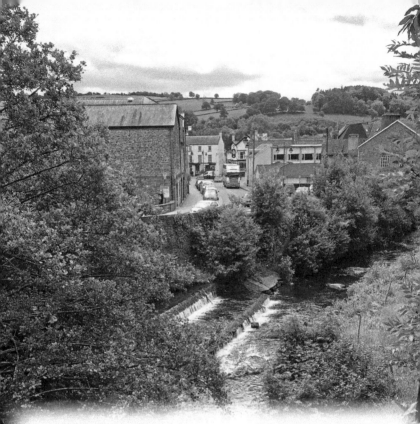

18. MARKET STREET

Market Street once ended at its junction with Castle Street but today it continues as Heol Gwasaneau. Market Street was mainly residential on its river side, ending at the hydro-powered sawmill of Williams Brothers builders. The remains of the weirs diverting water to the mill can clearly be seen here. Opposite the sawmill stood the Queens Head, which is now a car park. The relief road has forever changed the character of the area, taking the once popular Black Lion Inn, which stood in its path, into history.

19. THE POSTERN GAOL

The police station and a courtroom were once located at the Postern Gaol. Felons and debtors were held here, and not by all accounts in the lap of luxury. At one time the circuit judges crossed the river from their lodgings in the Struet, unseen and in safety, to dispense justice. Mr Harry Simmons, who resides at the Postern Gaol, may well be around and have some interesting yarns to tell.

20. THE CATHEDRAL YARD

The cathedral from the lychgate. Originally a Benedictine priory founded in 1093 by the Norman lord Neufmarché, monastic use ceased during the sixteenth century. A few minutes spent in the yard will be rewarded with some very interesting monuments. Look out for the grave of the holder of the Victoria Cross medal and another of a French officer prisoner who died here during the Napoleonic Wars. They are relatively easy to find.

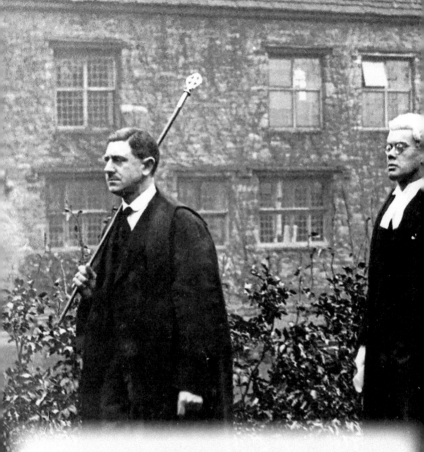

21. THE CATHEDRAL PRECINCTS

The solemn procession for the enthronement of Bishop E. W. Williamson in 1956 is led by cathedral verger Albert Tilley followed by John de Winton, registrar. The bishop is supported by chaplains Revd G. I. R. Jones and Revd N. L. James. Within the precincts are many interesting and historic buildings. Priory House, at the far end, is where Charles I stayed while passing through Brecon during the Civil War in 1645.

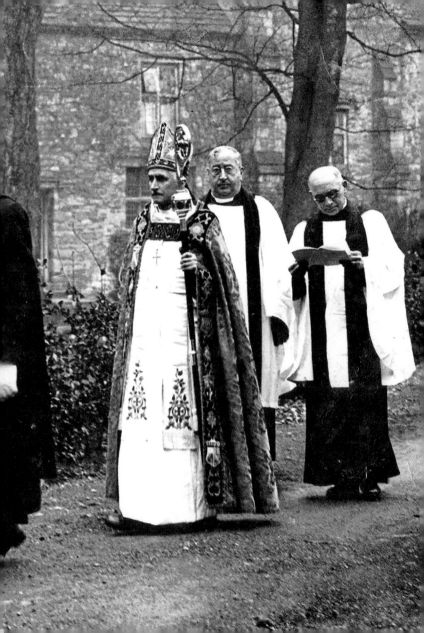

22. CATHEDRAL INTERIOR

In a glass case near the cathedral entrance are the signatures of the Queen, Charles and Camilla, and Archbishop Robert Runcie; perhaps more interestingly, are signatures of the eleventh Doctor Who, Matt Smith, and his assistant Amy Pond (Karen Gillan), who give their address as 'The TARDIS'. Nearby are items from the illustrious past of the 24th Regiment, including regimental colours from the Zulu Wars. Before you leave look for a relic of Agincourt, a stone on which Cordwainers from Brecon sharpened their arrows.

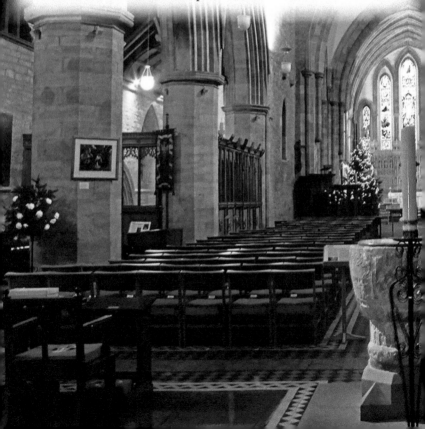

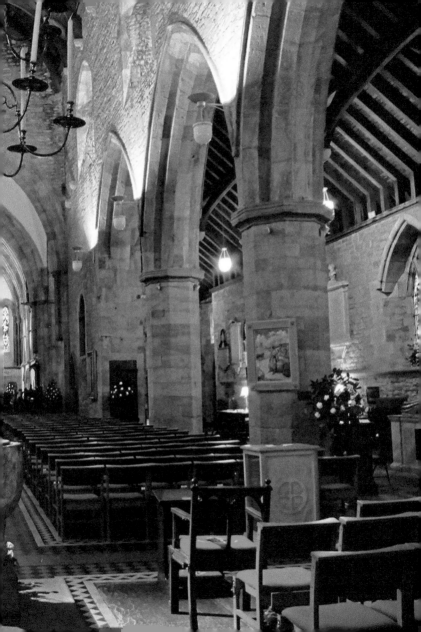

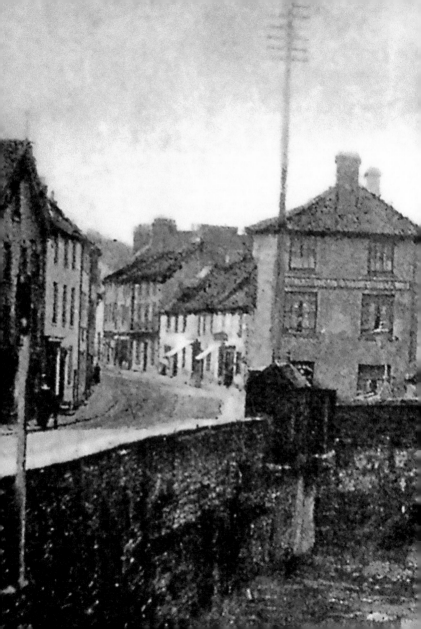

23. PRIORY BRIDGE

A flannel mill once flourished near the Priory Bridge. Now long gone, the area is recreational, but it is interesting to note that the other buildings in the picture (with the exception of the railway viaduct) remain virtually unchanged.

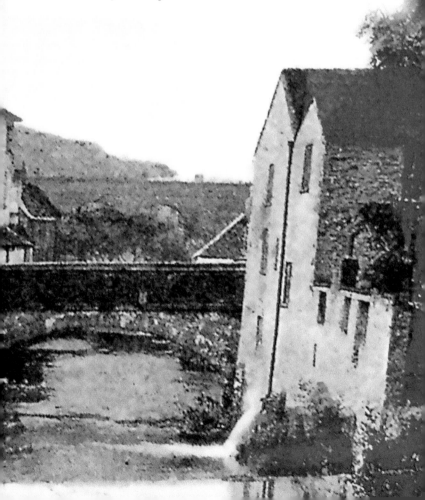

24. PRIORY GROVES FOOTBRIDGE

Looking north from the Honddu Bridge, this old postcard shows the footbridge leading to the Priory Groves, which is always a popular and pleasant walk. Note the remains of a system of weirs that drove the mills and the industry that flourished here. The Struet is almost entirely residential nowadays, but remnants of its industrial past are commonplace.

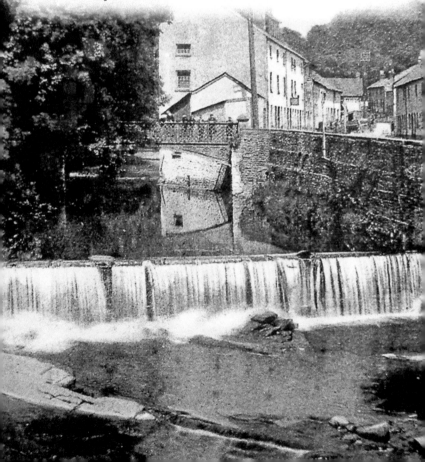

25. KING STREET

The quaint and often unexplainable names allotted to some of the streets of Brecon are quite perplexing – what is meant by 'The Struet'? The Bulwark, Postern, Superior and Inferior High Streets can be explained by their proximity to the castle, but King Street, or King Charles' Steps as it is locally known, poses another problem. We know that Charles I spent one night in Brecon in 1645 during the Civil War, but why is this quaint and ancient cobbled lane linked with him?

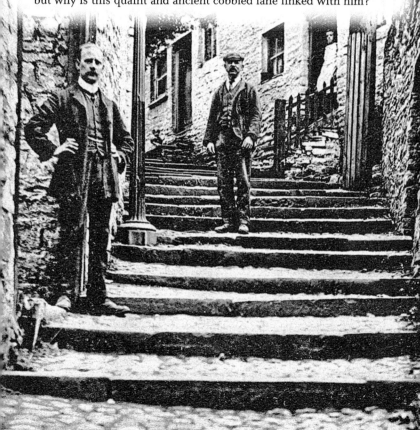

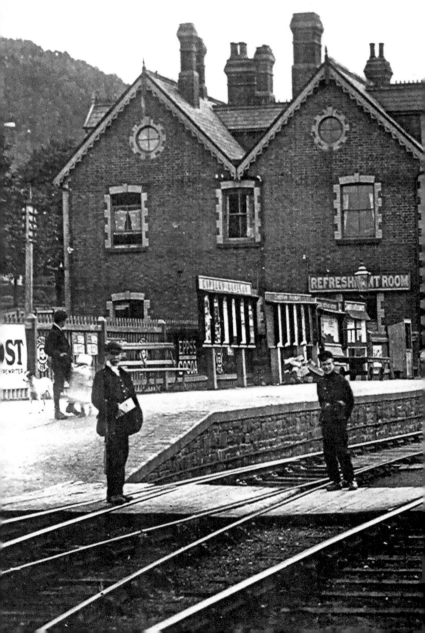

26. BRECON RAILWAY STATION

This image shows Brecon railway station in **Camden Road**. Several railways passed through **Brecon** and older Breconians **will remember** the Sunday school outings that left by train to the **exotic destinations of** Barry Island, Porthcawl and the like. Carriages **were crammed full** of excited children and their long-suffering parents. **The line closed in** 1964 and no trace of the station remains; Old Station **Crescent, a short road** nearby, is all that remains of our railway he**ritage**.

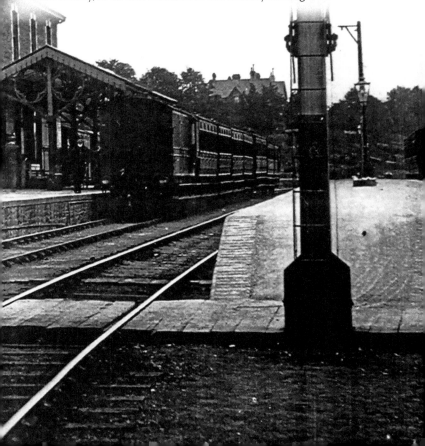

27. BETHEL SQUARE

The whole area around Bethel Chapel has been developed into a tasteful shopping mall, maintaining many of its original features. The chapel was once the largest in Brecon with seating for 800 people. It is built on the site of the Golden Lyon Inn, which gave Lion Street its name. Another chapel, Dr Cokes', stood nearby on land now occupied by a supermarket. The Plough Chapel is the only one remaining of the three Lion Street chapels.

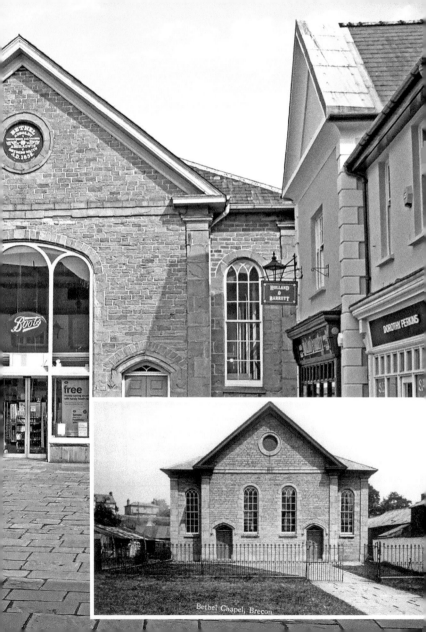

Bethel Chapel, Brecon.

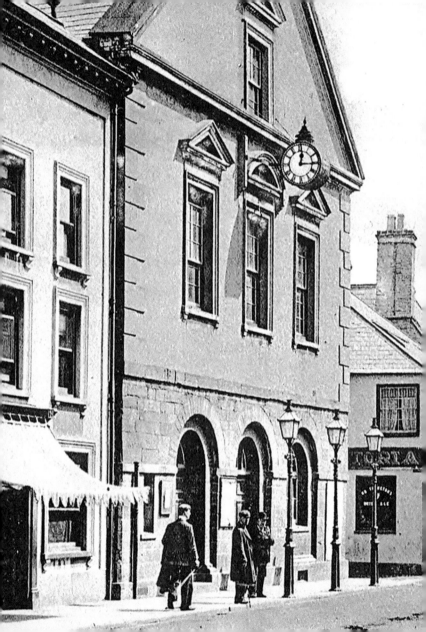

28. THE GUILDHALL

The High Street *c.* 1890. The ground floor of the Guildhall was originally an open arcaded market selling meat, cheese, butter, seeds, hops and other things. Beyond we see the Victoria Vaults, an inn soon after demolished and replaced by what is now the HSBC Bank. A barber's pole is visible on the right and the other buildings on this side of the street, with the exception of the one standing in what is now the church entrance, seem to have survived.

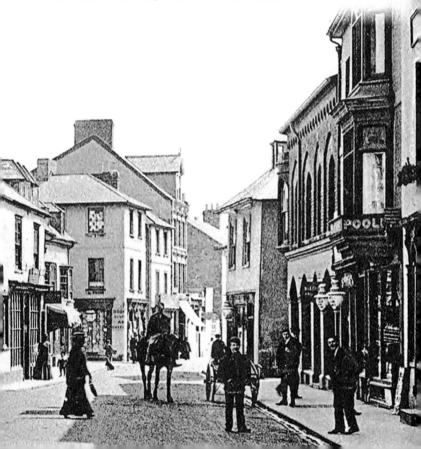

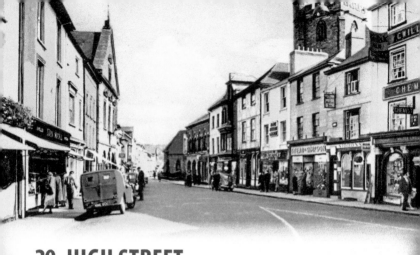

29. HIGH STREET

Two interesting views from the 1950s and 1960s. The Shoulder of Mutton Inn has changed its name during this time to honour the famous actress Sarah Siddons, born there in 1755. Many residents will fondly remember Gwillim's the chemist and Stan Mayall's jewellers shop (opposite by the red van). In the later photo the chemist is now owned by Mr Elliot, who is also fondly remembered, and Bradley's clothier has relocated from the corner of Ship Street.

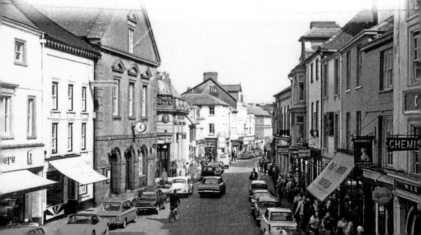

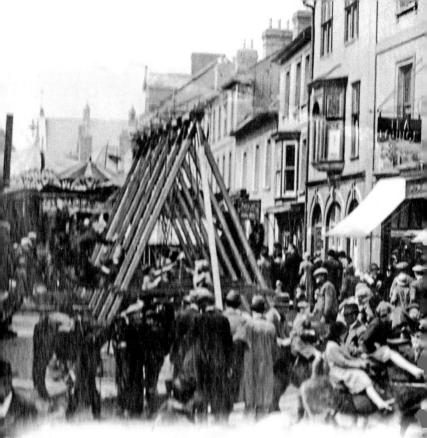

30. THE FAIR

A travelling fair occupies the town centre for two days every November and May. Although some may feel it is anachronistic, it continues to invoke its charter and has so far resisted all efforts to move it from the streets. Once the fair heralded the hiring of farm servants for the season. Members of the ancient Showmen's Guild often spend their entire lives with the fair, growing up with parents who themselves spent their lives there.

31. HIGH STREET SUPERIOR

High Street Superior is a trio of small but interesting narrow streets leading from Castle Street towards Ship Street and into High Street Inferior (which comprised the triangle from the Guildhall to Ship Street).

32. LION STREET/BELL LANE AREA

Ahead is the entrance to Lion Street and the Struet begins to the left. The entrance to the Struet was once known as Old Port Inferior. The archway opposite Lion Street led into the Bell Inn, one of Brecon's most prominent coaching inns. At the entrance to Bell Lane some interesting signage can be found: one dating from the era when Post Horses could be changed here and another small sign reminding children about road safety. A few yards beyond Bell Lane stands the town's indoor Market Hall.

33. THE MARKET HALL

The Market Hall was built following an Act of Parliament dated 1838. Friday has traditionally been market day and it remains a focal point where friends meet to enjoy a blether and wander around the assortment of stalls. Its entrance runs between two adjoining buildings and appears to have some age but the other structures seem to have been added later. A variety of events have been held here including professional wrestling matches, dancing and pop concerts by artists including The Hollies.

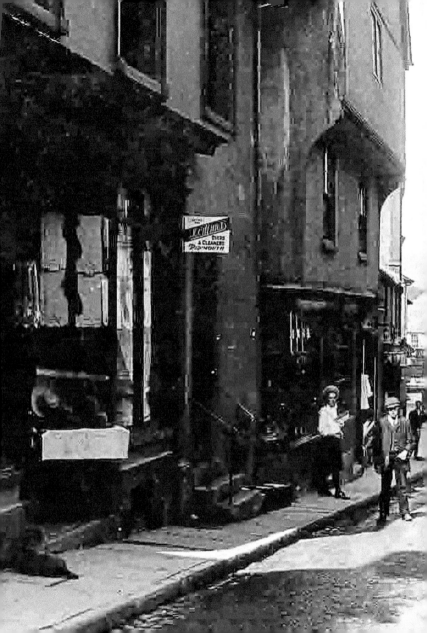

34. SHIP STREET

The top of Ship Street looking towards the bridge. It contains gorgeous medieval buildings and interesting narrow streets. Far too pretty to survive? Absolutely! Almost the entire northern side was redeveloped, but at least the south side remains. The town library replaced much of the northern side, and for a modern building it does have some merit as its walls and windows depict the pages of a book.

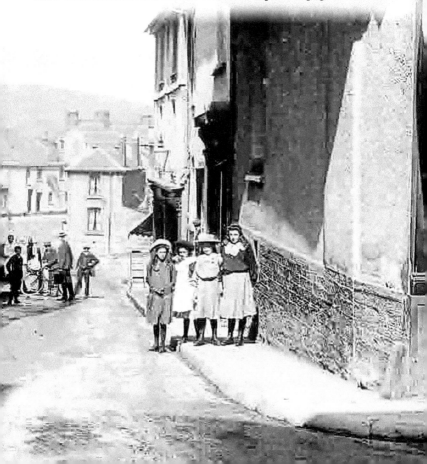

35. SHIP STREET

Ship Street from the bridge. The shot shows the entire row that was demolished in an earlier attempt to manage traffic. The planners are threatening to redevelop the entire area on the left of this picture up to and including Bell Lane. I suppose we need to await the results before passing judgement...

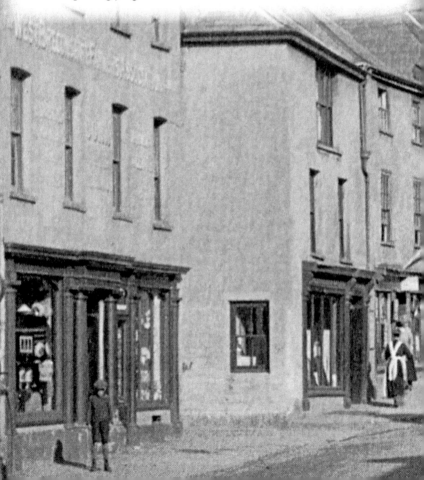

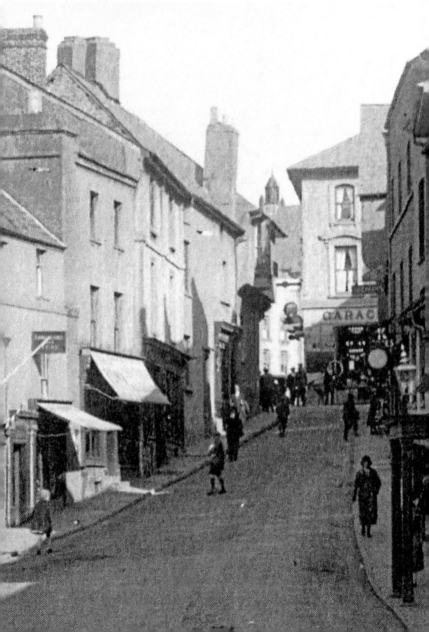

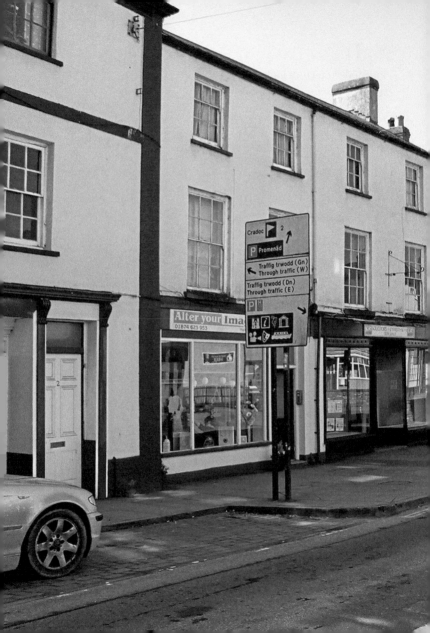

36. THE BRIDGE AREA

This modern picture looking down Ship Street shows the entrance to the narrow but interesting St Michael Street near the Usk bridge and also the Boar's Head Inn. On the wall nearby is a plaque reminding us of one of the worst floods in history. To the right a new road encourages traffic along Market Street away from the town centre.

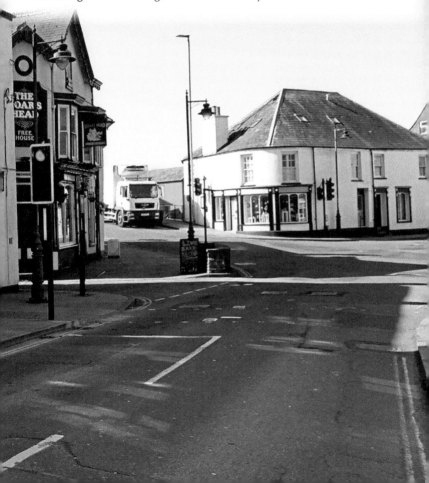

37. WHEAT STREET CORNER

Ship Street is a mutated form of the original name 'Sheep Street', or 'Heol y Ddefaid' as it is on the bilingual street signage. Sheep were probably once openly sold on the streets here. Bradleys outfitters was a well-known shop next to the Coliseum cinema, which can just be seen here squeezed between was Lewis's barbers shop.

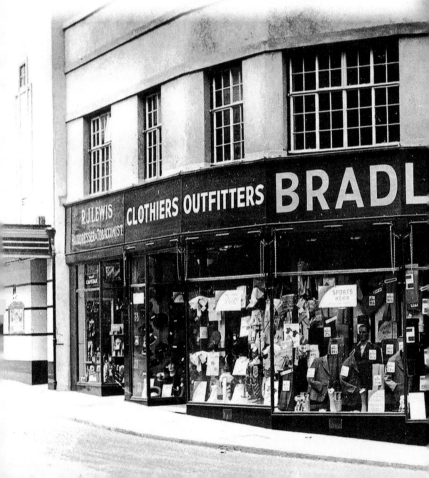

38. THE ELECTRO THEATRE CINEMA

The Electro Theatre Cinema located at what is now St Michael's Hall in Wheat Street. Did this cinema eventually evolve into Brecon's only surviving cinema – the Coliseum – just a few yards along the same street? The photograph was possibly taken at the opening of the cinema judging by the numbers present.

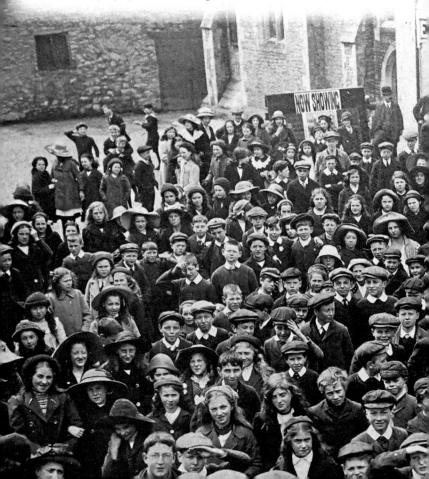

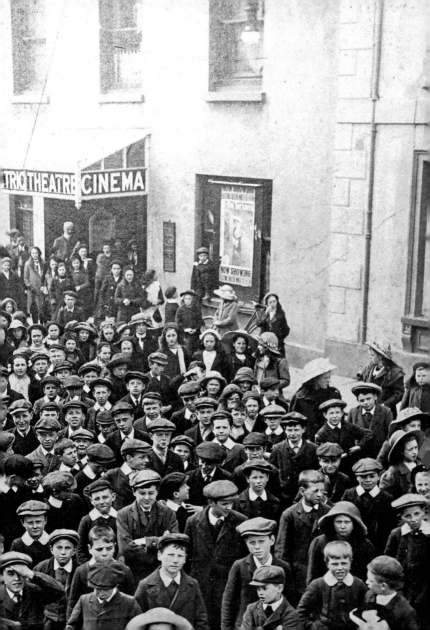

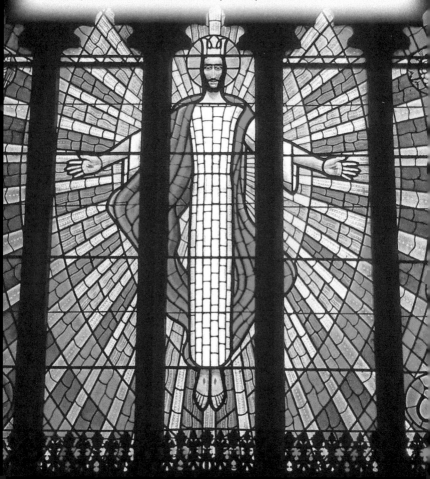

39. ST MARY'S

It is always worth visiting the Church of St Mary the Virgin in the centre of the town, but on sunny days around noon this wonderful stained-glass window captures the sunlight to provide an awesome sight. The iconic Buckingham Tower was built by the last Duke of Buckingham, who was beheaded by Henry VIII.

40. STEEPLE LANE

Steeple Lane seems a strange name for the short lane that runs behind the church. A steeple indicates a tall tower topped by a spire and a belfry, but this is most definitely a tower. Nevertheless, it is an interesting part of the town centre. Seek out the dog door in the church.

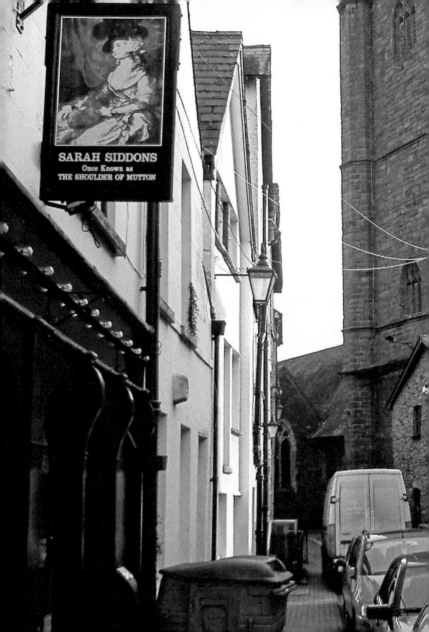

41. CHURCH LANE

The rear of The Shoulder of Mutton Inn in Church Lane. The famous actress Sarah Siddons was born on here on 5 July 1755. The original name of the inn has been changed in favour of the name of the actress. Another of the many interesting back streets of Brecon.

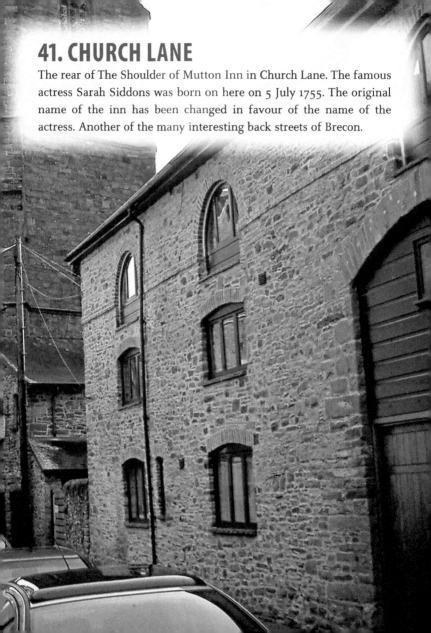

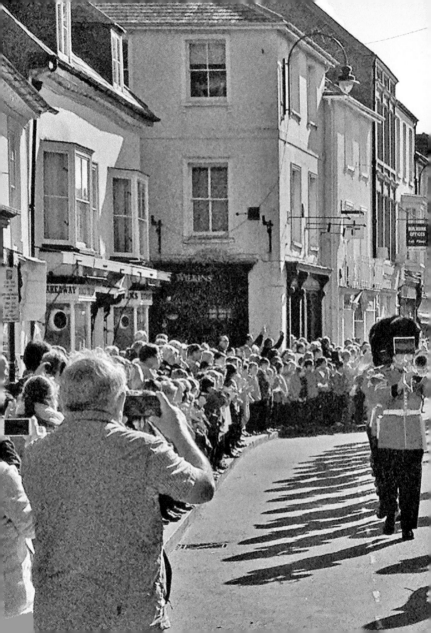

42. MILITARY LINKS

Many famous regiments have at one time or another made Brecon their home. The Parachute Regiment's battle school was once located here but Dering Lines is nowadays a centre of excellence. Basic Brecon and Senior Brecon are legendary courses in military circles where the platoon commanders come to learn their trade. Here we see the Welsh Guards and their regimental band in 2011, exercising the freedom of the borough, an honour bestowed upon them and several other regiments.

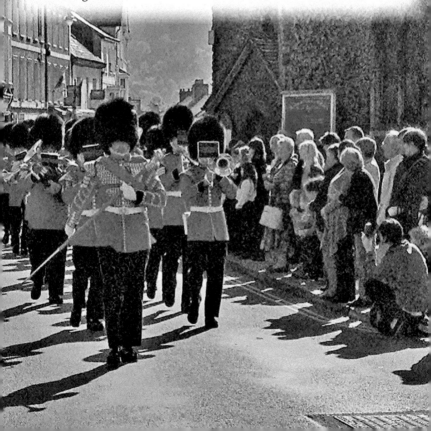

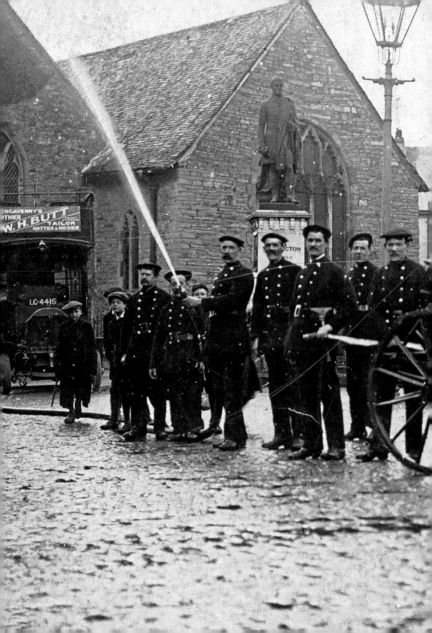

43. BULWARK AFTER THE FAIR

Brecon Fire Brigade cleaning up the Bulwark after the fair around 1912. The building that was to become the once famous Café Royal is occupied by A. H. Tyler (plumber), and next door in temporary accommodation is the London and Midland Bank, which evolved into today's HSBC Bank. I guess that their current premises were under construction when this was taken. The open-top omnibus on the left is worth a look too.

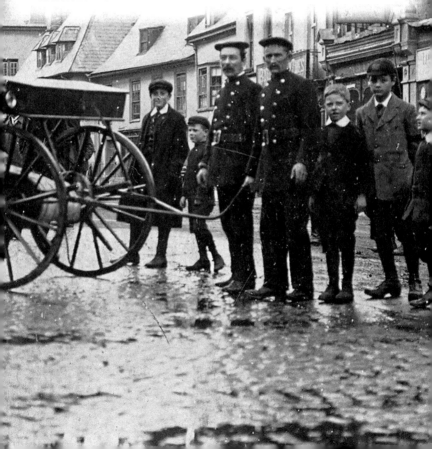

44. THE BULWARK, 1980s

The Bulwark during the early 1980s. Owen's China Store was always popular, the floors above comprising the Bulwark Hotel – a short-lived enterprise if my memory is correct. Along the street Pearl Assurance is a name that has disappeared, also the Electricity shop and Bulwark Radio. The next business, taking the whole of the ground floor of the smallest building in this row, was F. H. Jones' Newsagent & Stationer, a veritable warren that was always popular. The only business that seems to have survived is the *Brecon & Radnor Express*, whose offices are on the right-hand side.

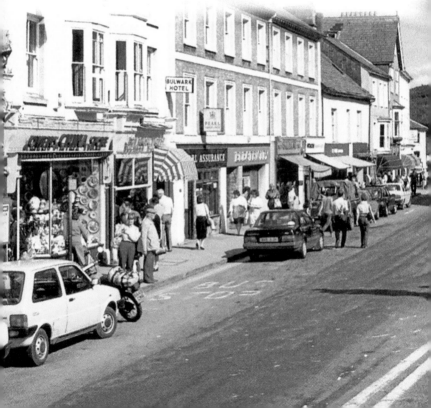

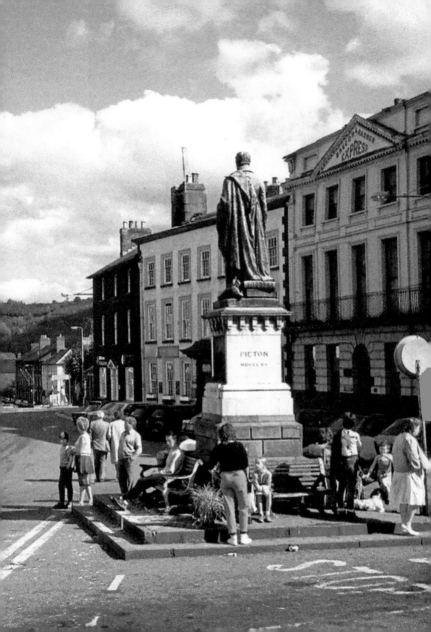

45. WELLINGTON/ST MARY'S STREET

A view of the Bulwark and the iconic Duke of Wellington statue surrounded by iron railings. Benches have long since replaced the cage that once protected the 'Iron Duke', allowing the weary to reflect on matters of the day. It was a cobbled area at the time of this view.

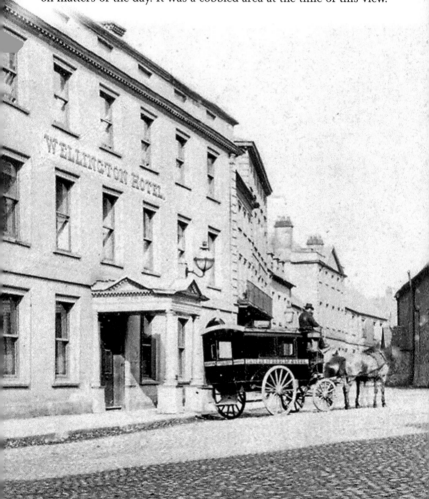

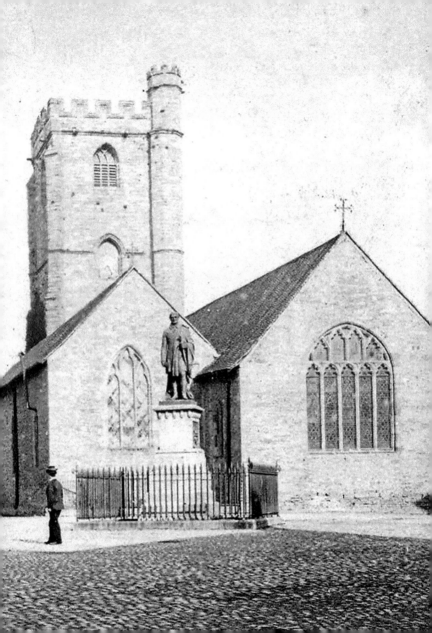

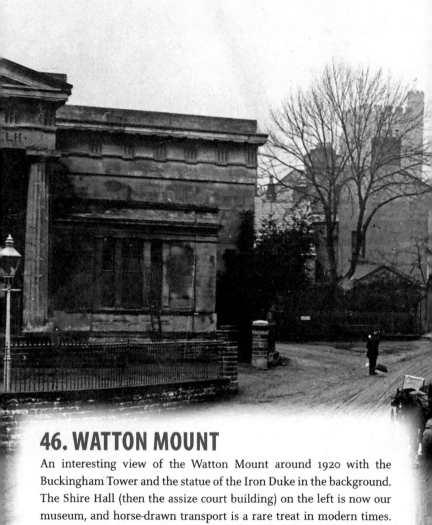

46. WATTON MOUNT

An interesting view of the Watton Mount around 1920 with the Buckingham Tower and the statue of the Iron Duke in the background. The Shire Hall (then the assize court building) on the left is now our museum, and horse-drawn transport is a rare treat in modern times. The inset shows the remains of the East Gate into the town, which is located behind the building on the right of the main picture.

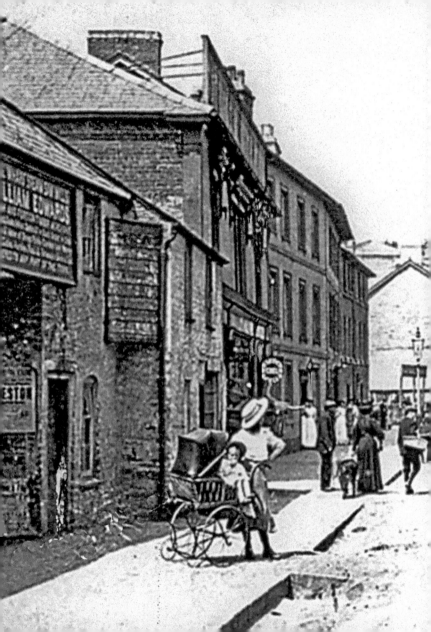

47. THE WATTON

An early photograph from the Watton, one of the main arteries into the town. The first few buildings on the extreme left are gone, but that aside the street is still recognisable.

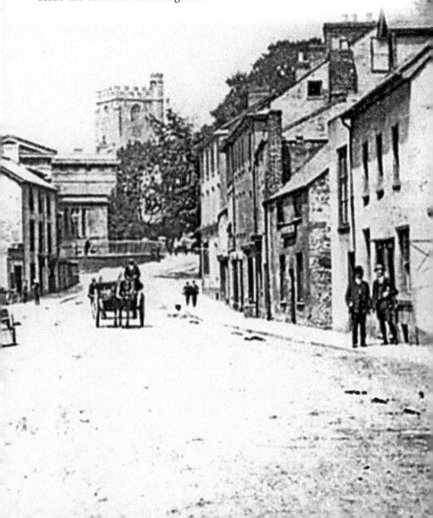

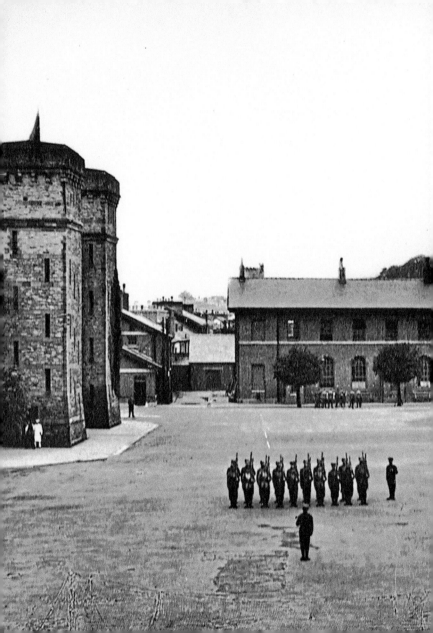

48. THE BARRACKS

The 23rd and 24th Regiments are two of many units to have made their headquarters here in Brecon and the association continues. Both now form the Royal Welsh Regiment's 1st battalion. The Regimental Museum in the building facing us holds artefacts from many campaigns including the defence of Rorke's Drift. The barracks was built in 1840 and is currently the headquarters of 160 Brigade (HQ Wales). The Royal Welsh now operates as the lead armoured infantry task force in the British Army.

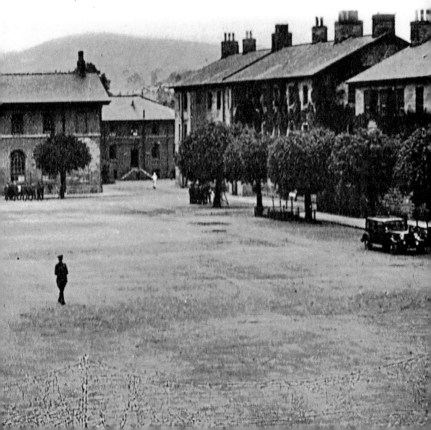

49. THE CANAL BASIN

The very pretty canal basin is purely recreational these days, but in their heyday the canal wharfs stretched upstream as far as the Captains Walk and some berths occupied what are now some of the streets of the Watton. Today the town's theatre stands proud and canal boats berth in one of the prettiest parts of town.

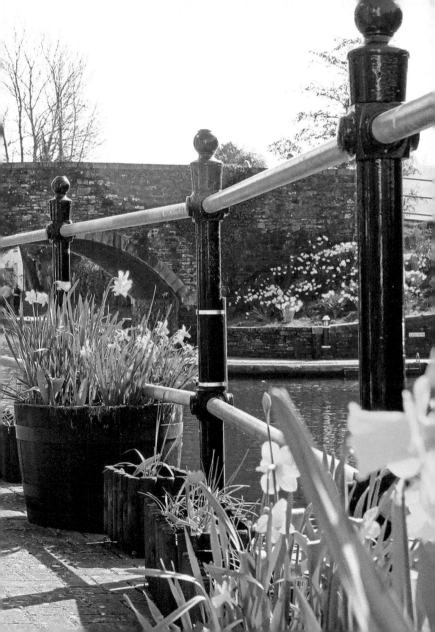

ACKNOWLEDGEMENTS

I would like to sincerely thank the Clark family, David Williams and all the kind people who have allowed me once again to use their wonderful photographs to enhance this publication. Also my wife, Sue, who has been a rock, giving encouragement and support throughout, and of course to Amberley Publishing, who conceived the idea for this book and have supported me throughout its production.

While every effort has been made to ensure accuracy and to gain permissions for the pictures used, for any error or omission I can only offer my sincere apologies.

Below: Workmen near Brecon, *c.* 1930.

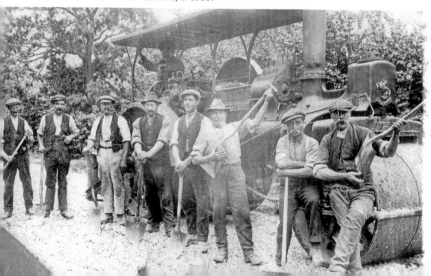